The Beginner's Guide
Chinese Painting

Flowers

by Mei Ruo

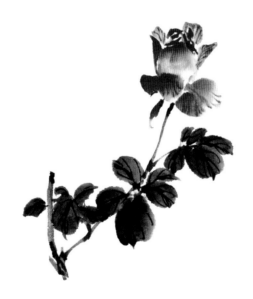

Better Link Press

This book is edited and designed by the Editorial Committee of *Cultural China* series.

Managing Directors: Wang Youbu, Xu Naiqing

Editorial Director: Wu Ying

Editor (Chinese): Shen Xunli

Editor (English): Zhang Yicong

Editing Assistant: Jiang Junyan, Abigail Hundley

Text by Mei Ruo

Translation by Yawtsong Lee

Interior and Cover Design: Yuan Yinchang, Li Jing, Xia Wei

ISBN: 978-1-60220-110-1

Address any comments about *The Beginner's Guide to Chinese Painting: Flowers* to:

Better Link Press

99 Park Ave

New York, NY 10016

USA

or

Shanghai Press and Publishing Development Co., Ltd.

F 7 Donghu Road, Shanghai, China (200031)

Email: comments_betterlinkpress@hotmail.com

Computer typeset by Yuan Yinchang Design Studio, Shanghai

Printed in China by Shenzhen Donnelley Printing Co. Ltd.

5 7 9 10 8 6 4

Contents

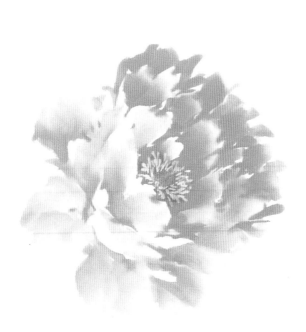

Preface

Peonies, lotuses, Chinese roses and irises are traditionally considered some of the most beautiful flowers by Chinese people. They have captured the popular imagination because Chinese people believe that the peony represents prosperity, the lotus unsullied purity, the Chinese rose eternal youth and the iris physical grace. These flowers have been favorite subjects in the creative efforts of China's poets and painters throughout its history. Mastery of the techniques used to paint these flowers will greatly benefit the painting of other flowers.

Lotus Blossom

The lotus, a staple in the time-honored flower-and-bird genre of Chinese painting, is another of the Chinese people's favorite flowers because of its showy flowers in full bloom, its grace and many charms. Its grace and charm have earned it eternal admiration among Chinese literati, and artists through the ages have never tired of trying to bring out its spirit in paintings. One reason for its popularity is the noble ability to "remain unsullied by its muddy environment." The lotus appears in Chinese painting in a wide variety of poses; it is the only flower that is paint-worthy in all stages of its life. Its large leaves afford the artists an opportunity to deploy and show off all their stock in trade in the use of brush and ink. The beginner should become acquainted with the morphology of the lotus to be able to paint it. He/she should first learn how to outline and dot a stem and a leaf, before going on systematically to learn the techniques of painting the flower and leaves of the lotus.

Morphology of the lotus

1. The lotus is an aquatic plant that grows in ponds. It is also cultivated in vats, pots or bowls. The flowers can be double or simple; the petals range from a dozen per flower to dozens. There may be one or multiple inflorescences per plant. Stamens mature into funnel-shaped seedpods. The leaves are round with ripple-like edges. New leaves are small, folded conic shapes when they emerge from the water, as vividly depicted in the verse line "Young lotus leaflets stick out their conic heads" (Fig. 1).

❶

2. The unopened flower bud is shaped like a ball, with the outermost petal unfolding first, followed by others opening one by one from the center outward until the flower is in full bloom. There are clearly distinguishable veins on the underside of the petals. When painting the petals, make sure all strokes converge, either visibly or invisibly, toward the center of the flower (Fig. 2).

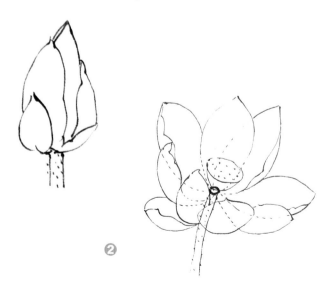

❷

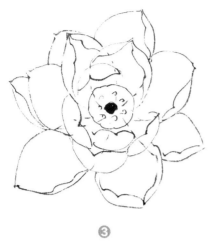

③

3. Before a flower wilts, a seedpod starts to develop. The petals fall away, leaving the funnel-shaped seedpod containing lotus seeds (Fig. 3).

4. The lotus has long, hollow, tubular stems with bristly down on its surface. The flowers, leaves and seedpods all grow from the top of these stems (Fig. 4).

5. The lotus leaves are large and shaped like round shields, with graceful ripple-like edges. The leaves are often painted in various postures: full front, side, underside, curled edges, vertical, etc. The veins on the leaves neatly radiate outward from the "navel" of the leaf (Fig. 5).

A lotus that grows in a pond is called a pond lotus. The orientation of its seedpod (front, side, prone or supine) is the orientation of the flower. The unopened, triangular flower buds must not be painted like candlesticks. New leaves are folded and pointed at two ends, with puny petioles; the leaves are veined. When a new leaf grows larger, the upper part will unfold first, before the lower half unfurls.

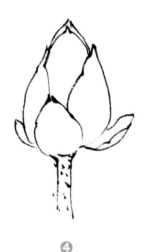

④

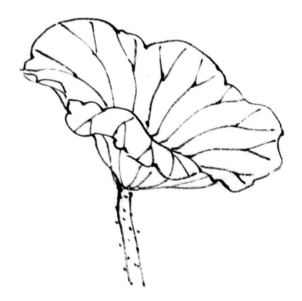

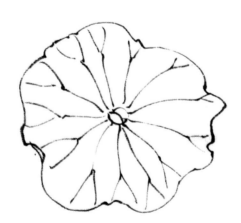

⑤

Painting a lotus flower half turned to one side

1. Paint the seedpod first, with a dark green made from gamboge and cyanine (Fig. 1).

2. Paint the petals with a goat-hair brush soaked in a thin white and tipped with eosin, in sure-handed, steady and naturally fluid strokes. Avoid rigidity though, because that would cause excessive bleeding and compromise the shape of the flower. Make sure you use side-brush strokes to paint the edges of the petals to minimize bleeding (Figures 2-7).

3. Touch up the petals with light green from the center of the flower outward to give a sense of three-dimensionality (Fig. 8).

Lotus leaves are suitable for painting with broad strokes in ink and therefore allow artists to show their ink and wash skills to full advantage.

Lotus leaves take up considerable space and weight in a painting and are often painted in the *mo gu* (or boneless) style.

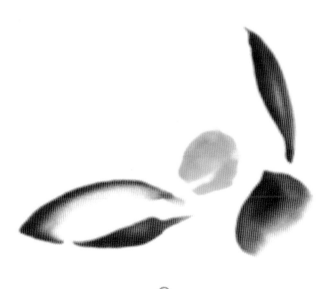

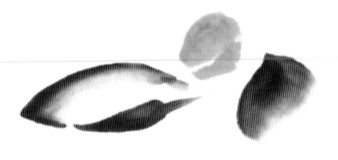

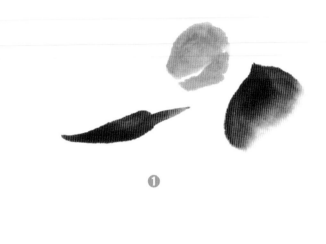

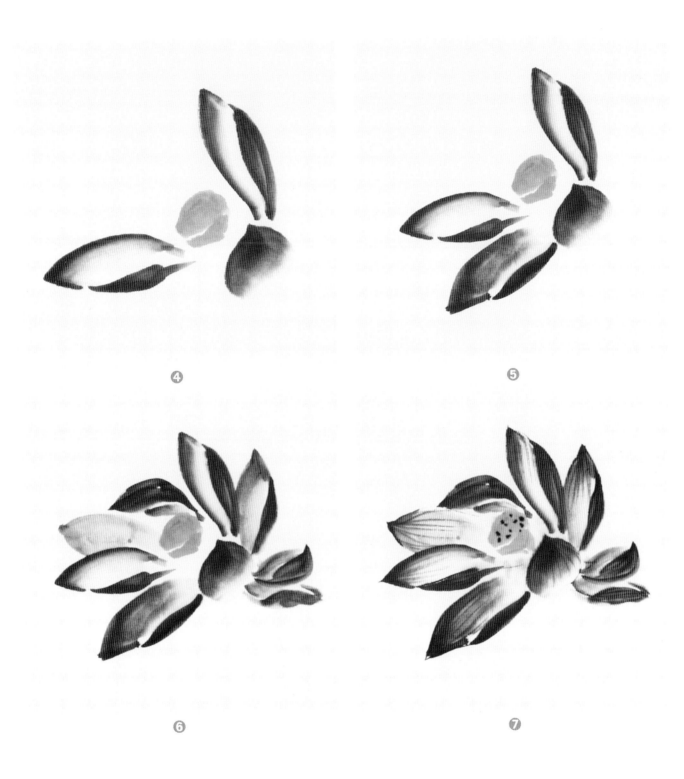

④

⑤

⑥

⑦

①

Painting lotus leaves in the *mo gu* (or boneless) style

1. Paint the leaves from the edge toward the center with a larger size goat-hair brush, soaked in water to its base and tipped with dark ink, using side-brush strokes. Make sure every stroke runs to the center (Fig. 1).

2. When painting to the edge of a leaf, remember to twist the brush around for a rounded look (Fig. 2).

3. The order of the strokes will ensure gradation in ink tone and wetness, sometimes with the brush pressed down to its base. Combine thick and slim, long and short strokes, and if need be, reapply ink to "break light ink with darker ink" or "break dark ink with lighter ink" to achieve a blending effect (Fig. 3).

②

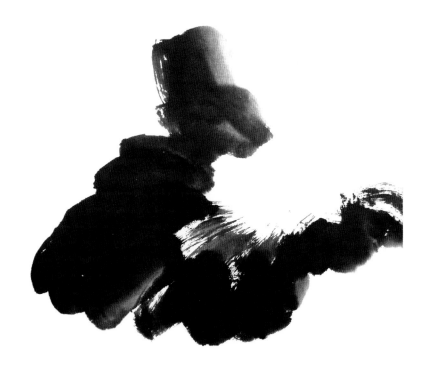

③

4. Toward the center of the leaves, use light ink to fill the blank space, but not completely covering it (Fig. 4).

5. If the leaves come out perfect, with variation in ink tone and wetness, you may skip the veins, but if you are not satisfied with the result, you can improve it by outlining the veins (Fig. 5).

6. You can paint the young leaves in the foreground in dark ink and those in the background in lighter ink to impart a sense of depth (Fig. 6).

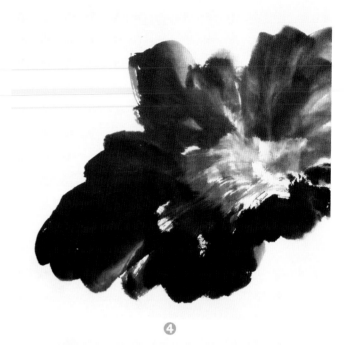

❹

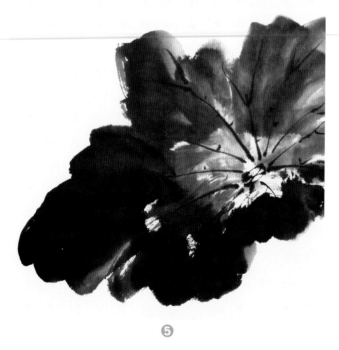

❺

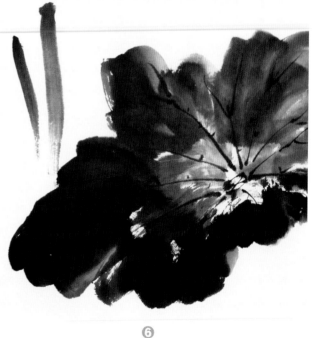

❻

Painting a lotus in the *mo gu* style

1. Paint the curled leaf edge in dark green and ocher (Fig. 1).

2. Paint the upside of the leaves in dark green mixed with ink (Fig. 2).

3. Paint the petals in two side-brush strokes with a brush soaked in water and dipped in a thin white, tipped with eosin. Execute the strokes in a brisk manner; make sure the petals point in various directions to avoid monotony (Figures 3-6).

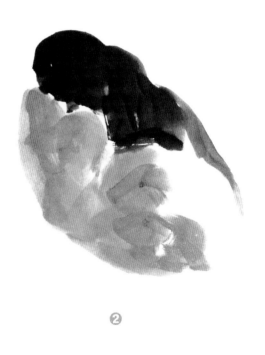

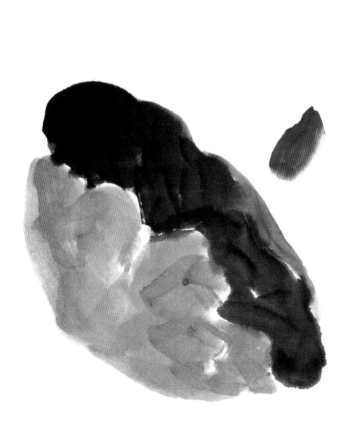

4. Paint the stem from the center of the flower. Dot bristly down on the stems (Figures 7-8).

5. To create contrast to the flower, outline the leaf veins with an outlining brush (Fig. 9).

6. Outline the center of the flower with rouge and a small amount of ink. Add some waterweeds when the ink and colors dry (Figures 10-11). Parallel lines are taboo in most cases in Chinese painting; correct them by adding strokes and elements.

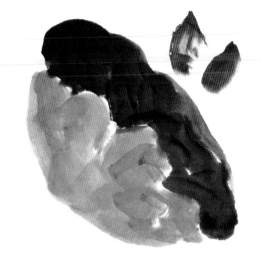

❹

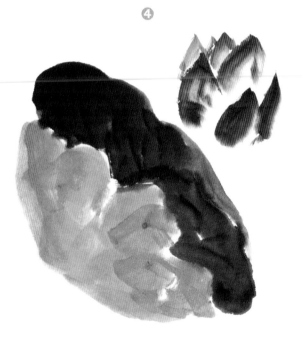

❺

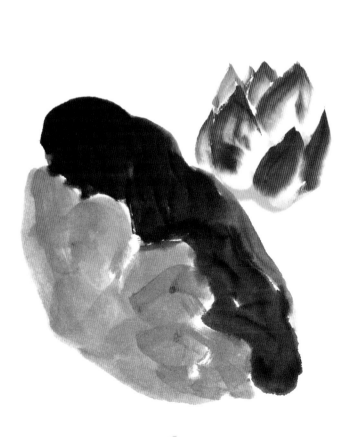

❻

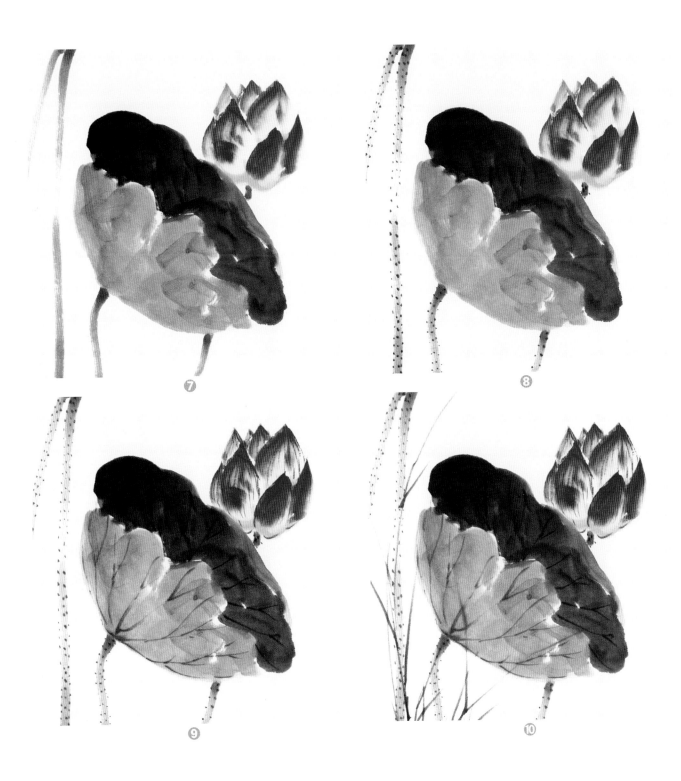

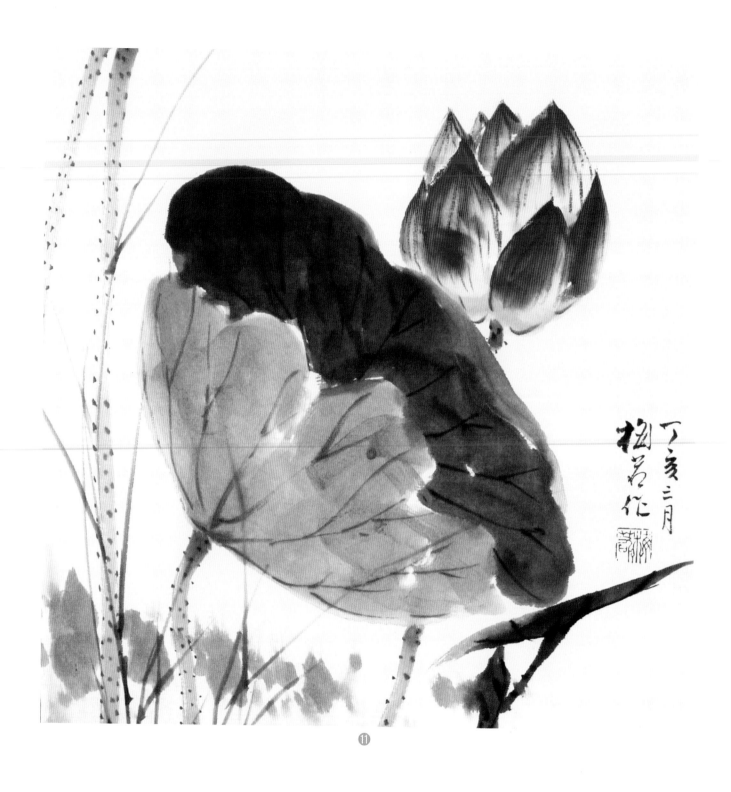

Example 1 (Figures 1-15)

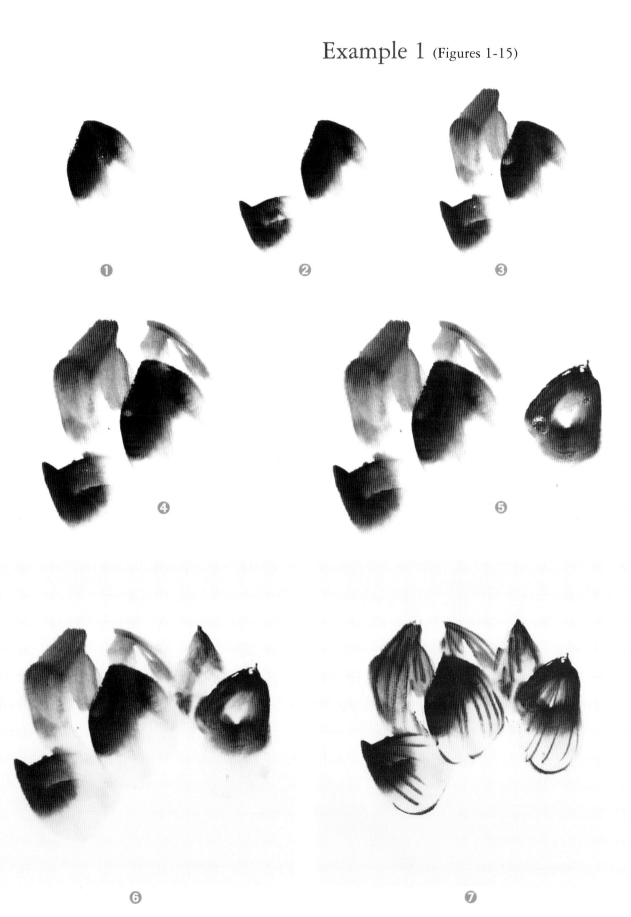

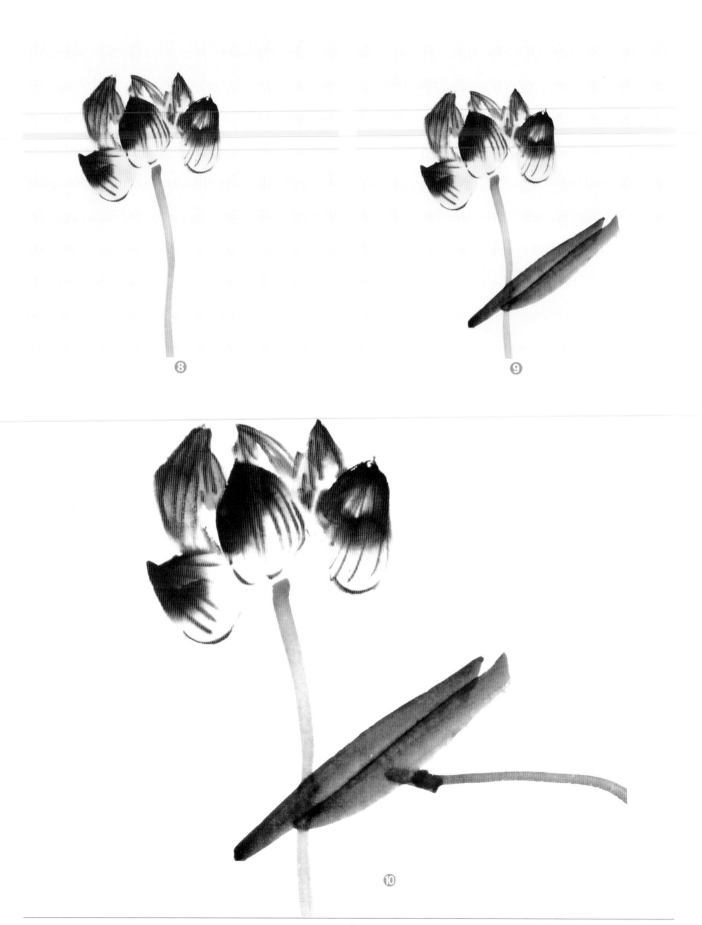

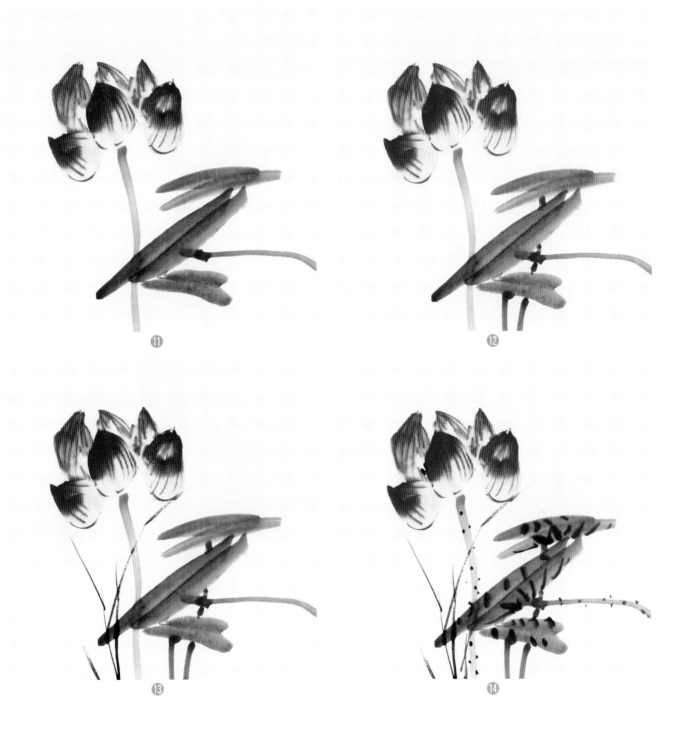

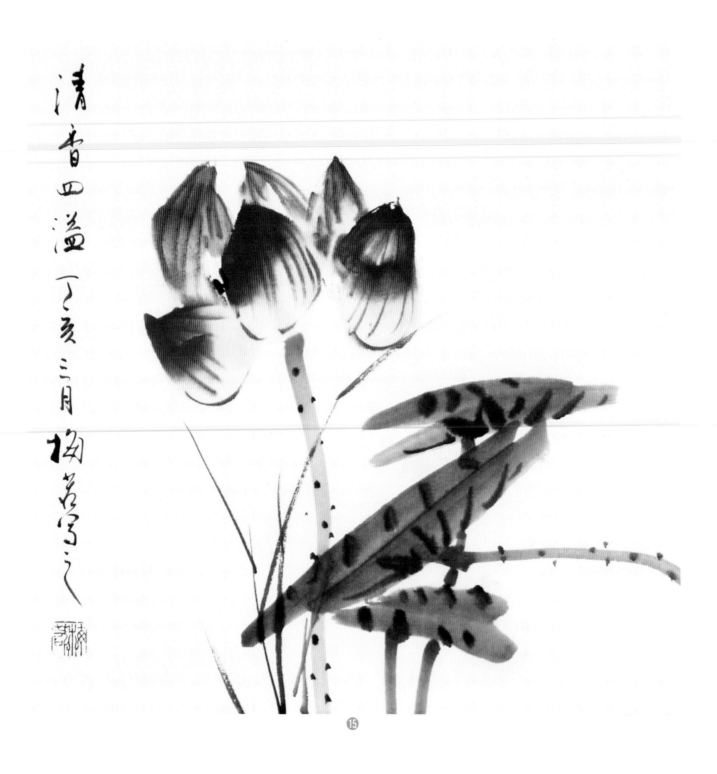

Example 2 (Figures 1-14)

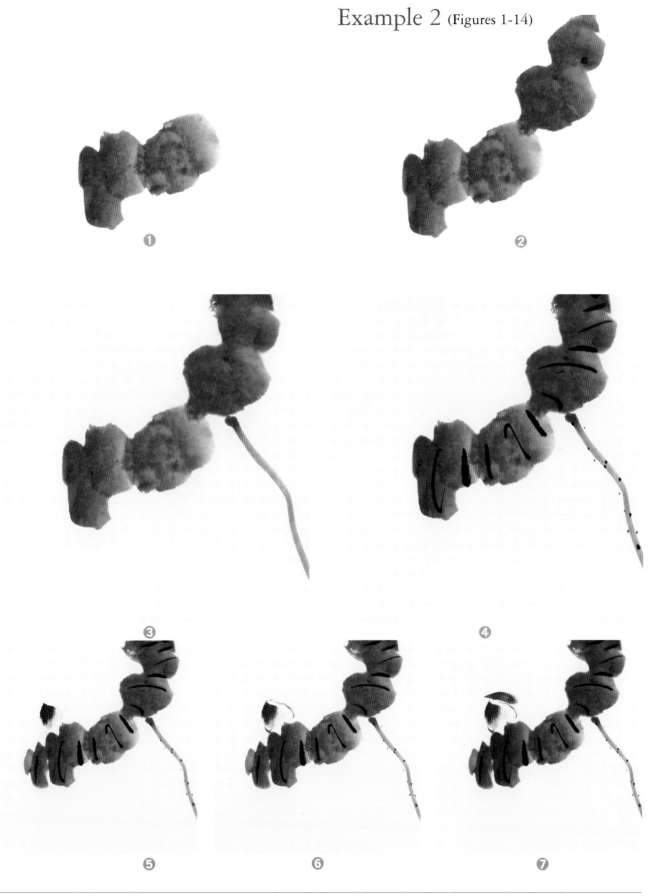

① ② ③ ④ ⑤ ⑥ ⑦

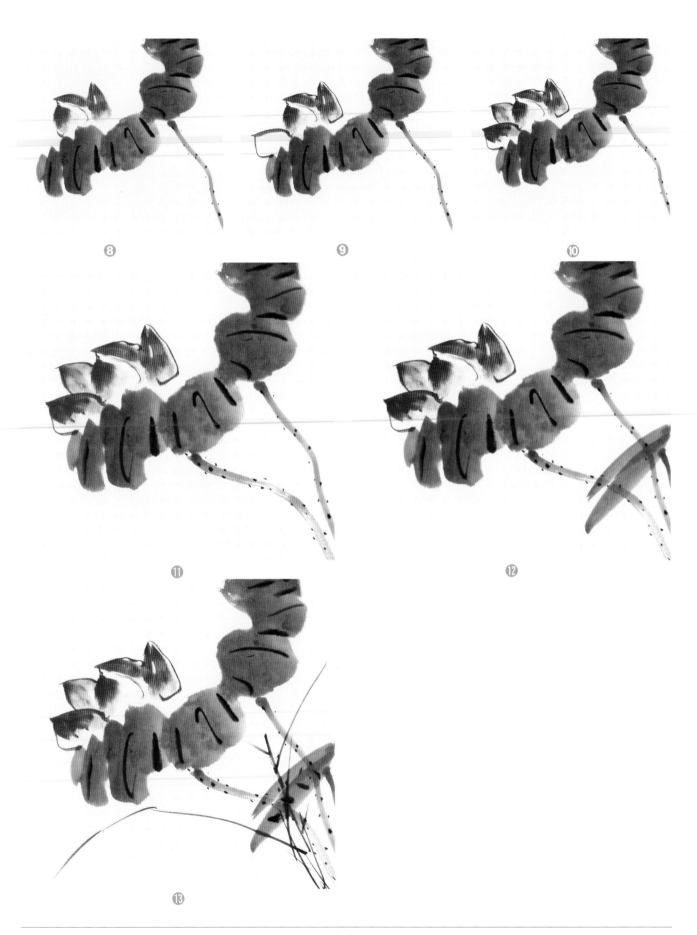

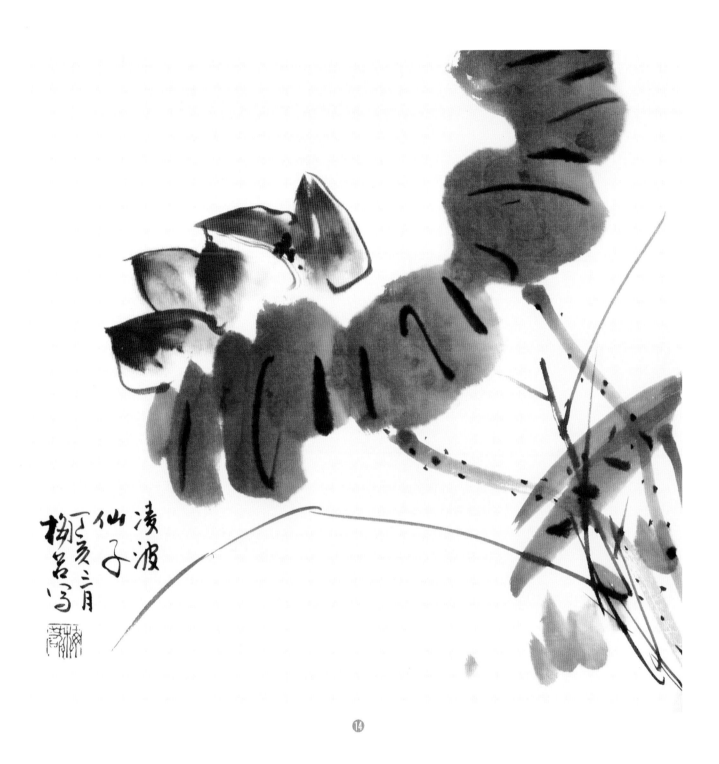

Iris

The iris is also called *yan zi hua* (swallow flower) or *hu die hua* (butterfly flower) by Chinese people. It has close to 150 cultivars. Irises in myriad colors are popular in city parks and green spaces.

Morphology of the iris

The iris blossom has three upturned petals and three often down-turned petals at an angle of about 120°. The iris comes in many colors, including lavender, yellow, white, blue, red, violet blue. Properly outlined veins on the petals will accent the beauty of the blossom.

When viewed from above, the veins appear to curve outward; the veins on the upturned petals are more intricate, narrowly spaced near the center of the flower and wider apart toward the outer edge (Fig. 1).

Painting a flower bud

Outline the veins in white, following the curves of the veins (Figures 2-3). The leaves of the iris resemble those of the orchid, only wider.

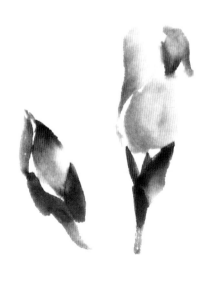

②

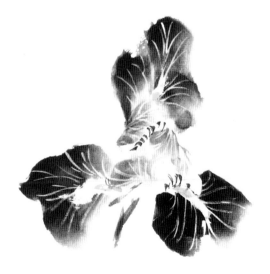

①

③

Painting an iris in the pseudo-*xie yi* style

1. Paint the petals in the middle with a brush dipped in a violet made by mixing eosin and cyanine, and tipped with a little bit of white powder (Fig. 1).

2. Wash off the white powder; then paint the outer petals in a deeper violet (Fig. 2).

3. Paint a petal in three strokes; in two if you can manage to dispense with the third (Fig. 3).

4. Before the petals dry, outline the veins on the inner and outer petals in a light violet; some artistic inventiveness is allowed in outlining the veins (Figures 4-6).

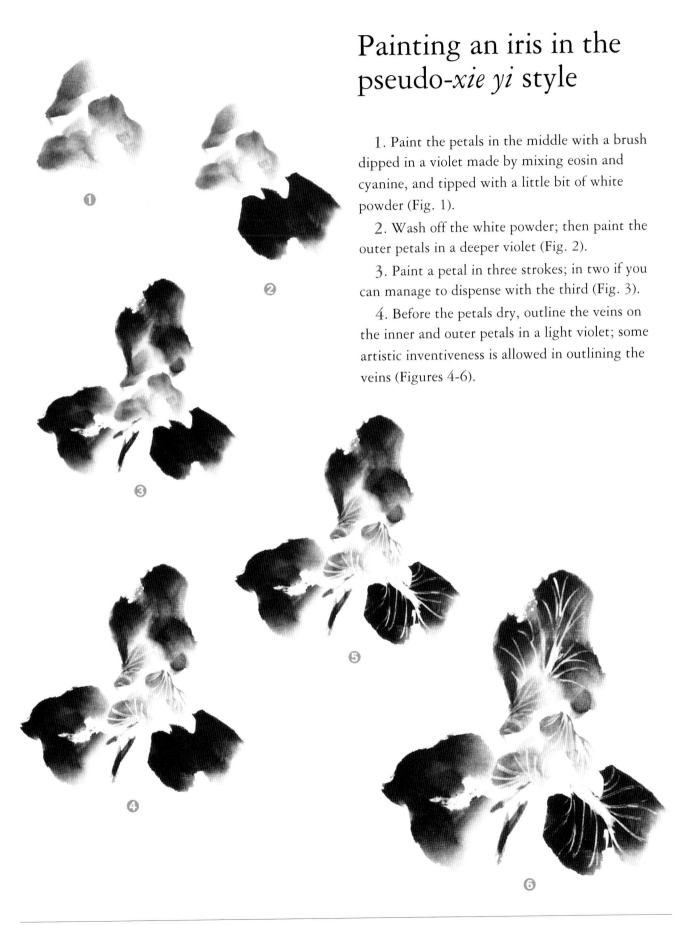

5. Dot the center of the flower with a yellow made by adding gamboge to a thick white (Fig. 7); finish up by adding leaves (Figures 8-11).

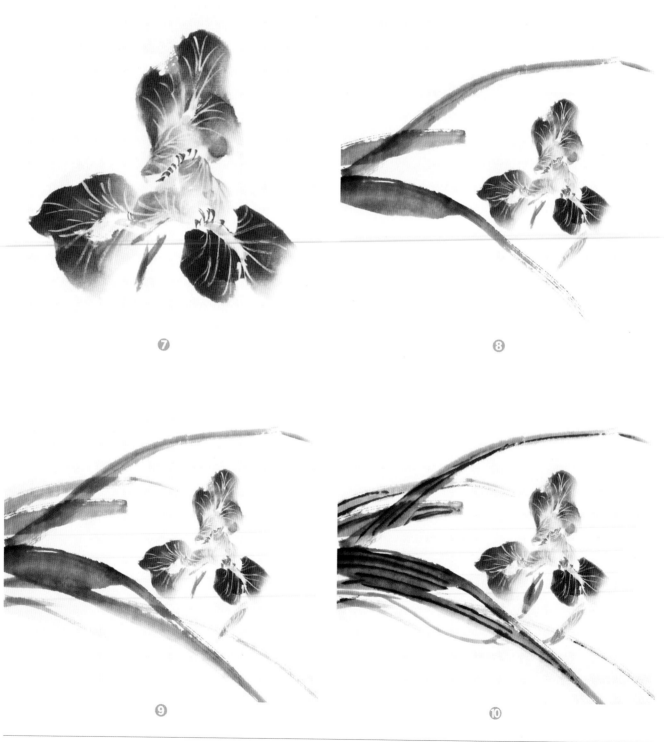

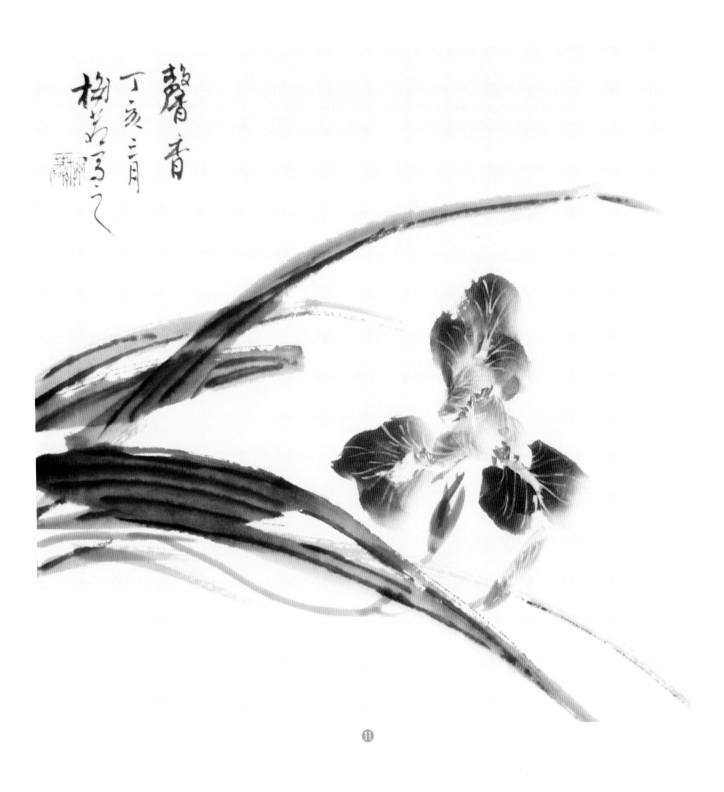

Apply the same technique to paint irises in different colors.

Painting a blue iris in beryl blue

Paint the inner petals in blue and the outer petals in dark green; outline the veins in white mixed with gamboge. Don't make the petals look too stiff; rather they should be curvaceous.

❶

Painting an upright blue iris

1. Paint the petals in cyanine; outline the veins in ink (Figures 1-4).

2. Paint the leaves with a brush dipped in dark green and tipped with a bit of ink (Figures 5-8); try adding a rock in ocher mixed with a little ink. You can also paint a butterfly on the flower bud.

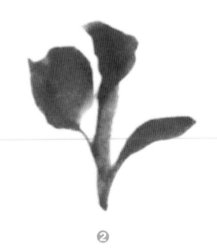

❷

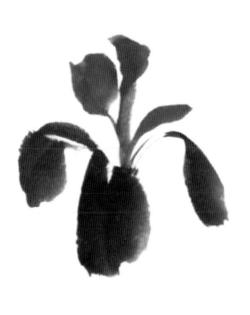

❸

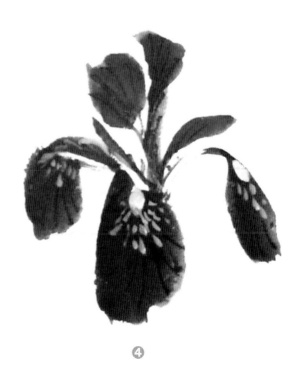

❹

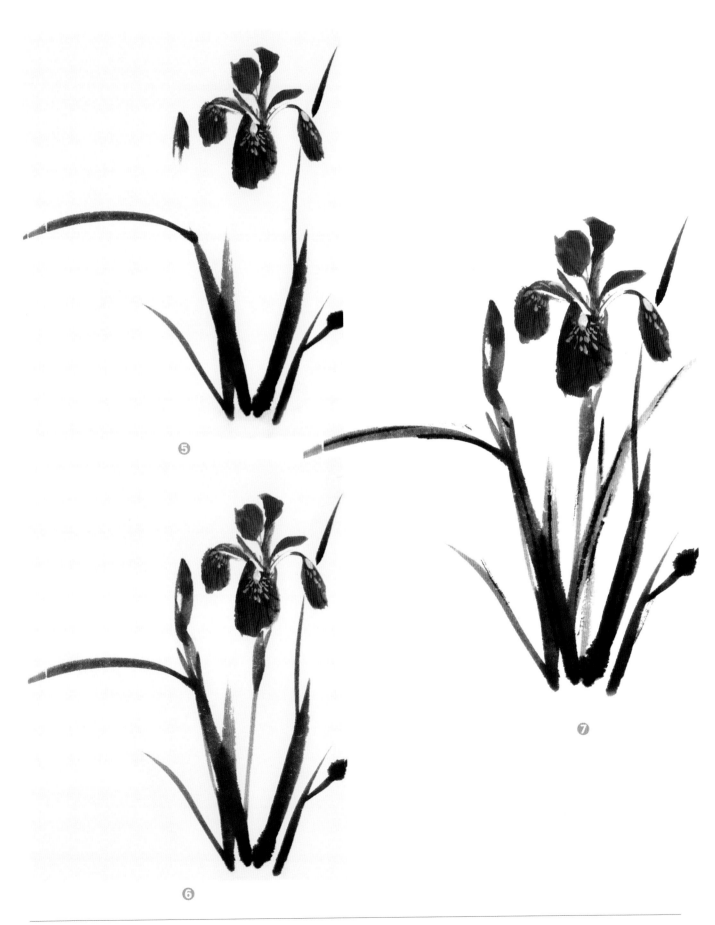

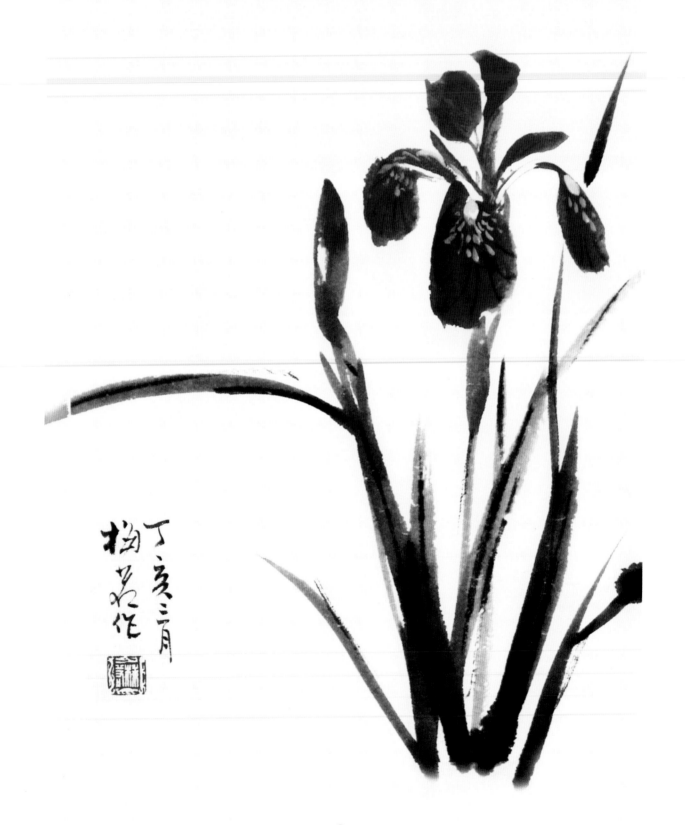

Painting an iris in violet, one of the most often used colors for irises

1. Paint the inner petals with a light violet and the outer petals in a deep violet, outlining the veins in light violet (Figures 1-6).

① ② ③ ④

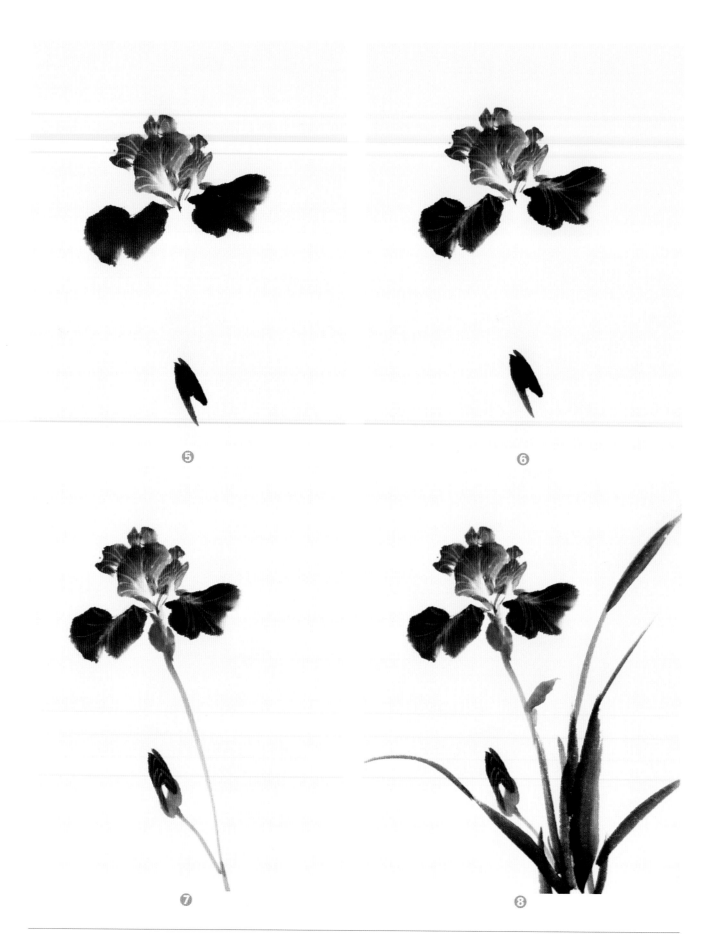

2. Paint the leaves with a brush dipped in dark green and tipped with cyanine; the leaves should have a clustered feel (Figures 7-8).

3. Paint the veins in dark ink using the *tuo bi* (pulling, with the brush inclined in the direction of the stroke and the tip pointing in the opposite direction) stroke, and accent the center of the flower with yellow (Fig. 9).

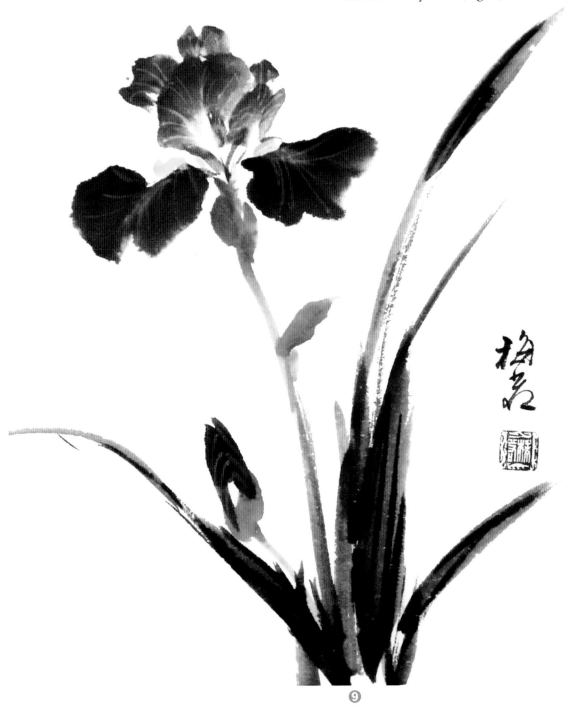

⑨

Peony

The peony boasts large flowers, bright colors and graceful leaves and stems. It has earned the reputation of being "a national and celestial flower," "unique among all the flowers," and "a flower of prosperity." It enjoys enduring appeal among Chinese artists and the populace. The peony comes in dozens of colors, notably pink, crimson, purple, blue, yellow, white and black. The wide variety of peonies has found expression in Chinese paintings through the brush of literati artists deploying their myriad techniques and styles.

The beginner who is interested in learning how to paint the peony and capture its beauty and spirit would benefit from a good understanding of its morphology and multifarious colors.

Morphology of the peony

The peony is a shrubby plant with stems of even thickness that branch out. Its main stem has a diameter not larger than that of a human wrist and its height does not exceed that of a human person (Fig. 1).

The older stems bear transverse markings. Each stem bears one bud with the leaf stem emerging from it (Fig. 1).

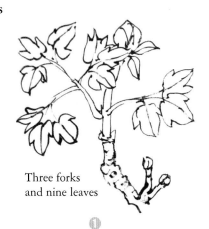

In early April the flower buds emerge from the leaf buds. As the stem lengthens, it branches out, sprouting new leaves (Fig. 2).

The leaves are alternate, biternate pinnate, with each petiole dividing into three petiolules topped by three leaflets. A full grown peony is therefore sometimes said to possess "*san cha jiu ding*," or three forks and nine leaves (Fig. 1).

Its flower may be simple or double, depending on the species; sometimes two flowers grow on one stalk, as in bing di lian, a lotus with twin flowers on its stem(Fig. 3).

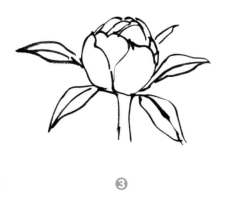

Three forks
and nine leaves

Painting four basic leaf forms

A leaf is normally painted in four or five strokes with a dark green made by mixing cyanine and gamboge.

1. The brush starts engaging the paper with light pressure, and then moves with the *bi du* ("belly" or midsection) of the brush pressed into the paper before being lifted off the paper, creating a form with a fat midsection and the two ends tapering to a point. (Fig. 1)

2. Repeat the same, overlapping somewhat the first stroke. Dot the leaf stalk.

Paint four leaves oriented in different directions and at different angles as shown (Fig. 2).

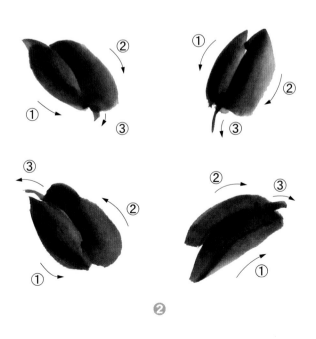

With practice, the student will be able to incorporate these different leaf forms into a leaved branch. The simplest composition of a leaved branch is a stem topped by three leaves. When painting the leaves, remember to give them a sense of perspective. They should face different directions (Fig. 3).

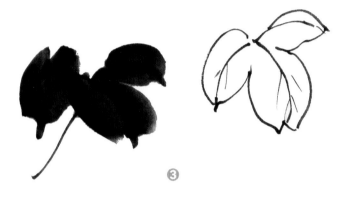

Painting a branch with nine leaves (Fig. 4)

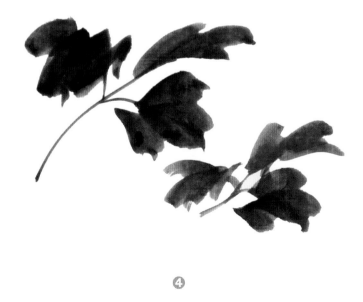

1. The leaf veins need to converge to one single point, toward the petiole. The main vein should be of varying thickness (fine-thick-fine) (Fig. 1).

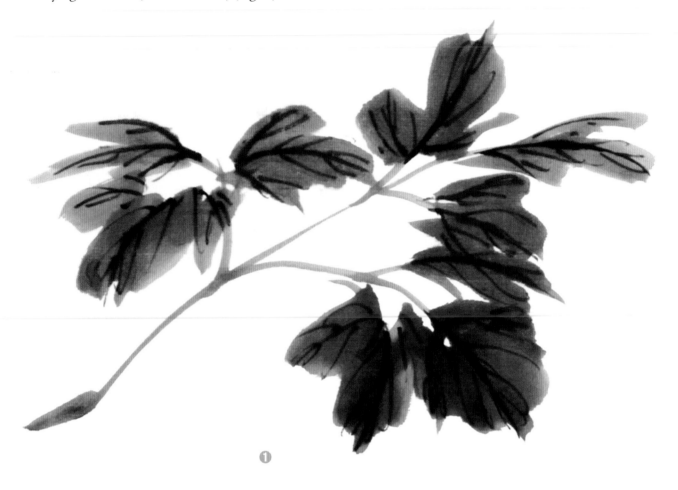

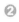

2. There should be three subveins on right and four on left, or three on left and four on right (Fig. 2).

3. Outline the veins before the ink on the leaf dries. Veins can be omitted on partially hidden leaves (Fig. 3).

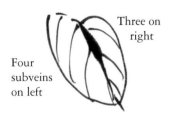

Four subveins on left

Three on right

Three on left

Four on right

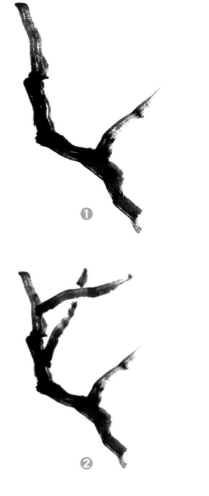

Painting branches on an old trunk

1. Paint the crooked trunk with a brush dipped in ocher and tipped with a bit of ink, pressing the brush flat against the paper. Remember to leave *fei bai*, or "flying white" (broken ink washes). The strokes should be light and brisk (Fig. 1).

2. Compose the branches to form a crisscrossing pattern that looks like the Chinese character " 女 " (Fig. 2).

3. You can touch up the edges of the trunk with ink; dab the trunk with a brush dipped in dark ink in short sideways strokes to bring out the transverse markings on the trunk (Fig. 3).

4. After adding the buds by dotting with a brush dipped in reddish dark green tipped with rouge, the old tree trunk is completed (Fig. 4).

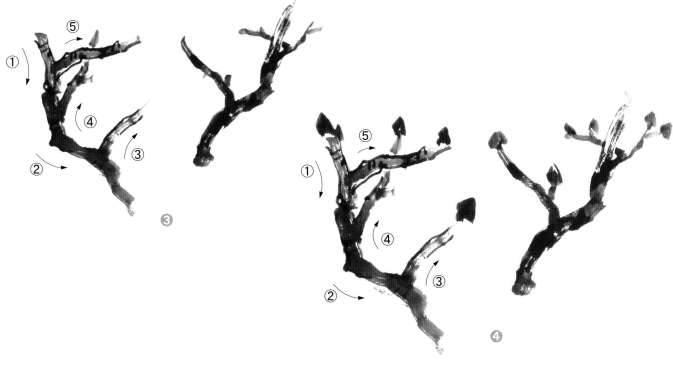

Painting flower buds

1. Use a brush dipped in a yellowish dark green made by mixing gamboge with cyanine and tipped with rouge.

2. Paint the sepals enveloping the unopened flower in two strokes (Figures 1-2).

3. Paint the upper half of the bud with a brush dipped in white and tipped with rouge (Fig. 3).

4. Paint the stem and the hanging sepals, and outline the leaf veins with a brush dipped in yellowish dark green tipped with rouge (Fig. 4).

①

②

③

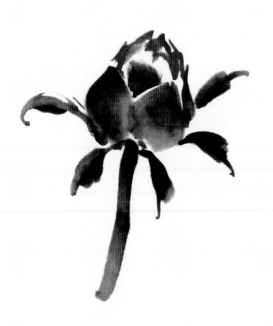

④

5. Paint another flower bud at a different angle, using the same technique (Figures 5-8).

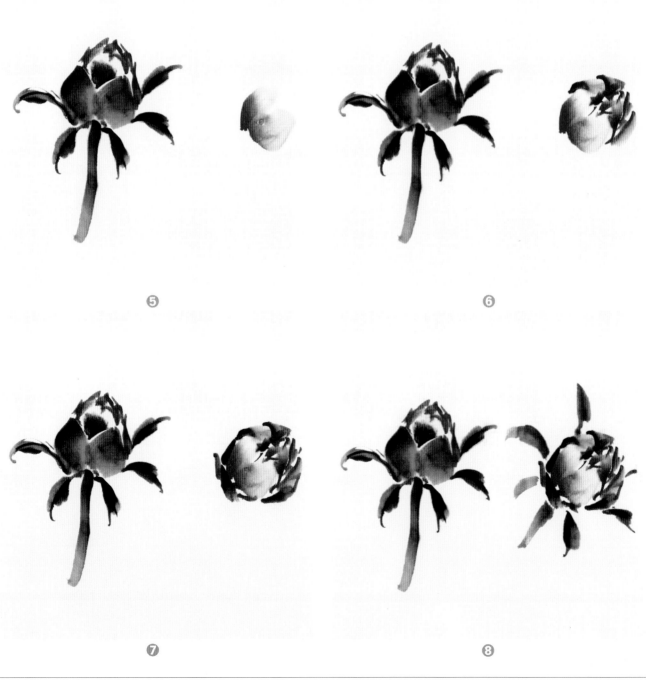

⑤ ⑥

⑦ ⑧

Painting the inflorescence of a peony

Once you master the basic strokes used in painting the four basic petal forms in a peony as shown in Fig. 1, you are ready to paint a peony flower.

The trick is to complete a petal form in two side-brush strokes with a brush dipped in a thin white and tipped with rouge (Figures 2-3).

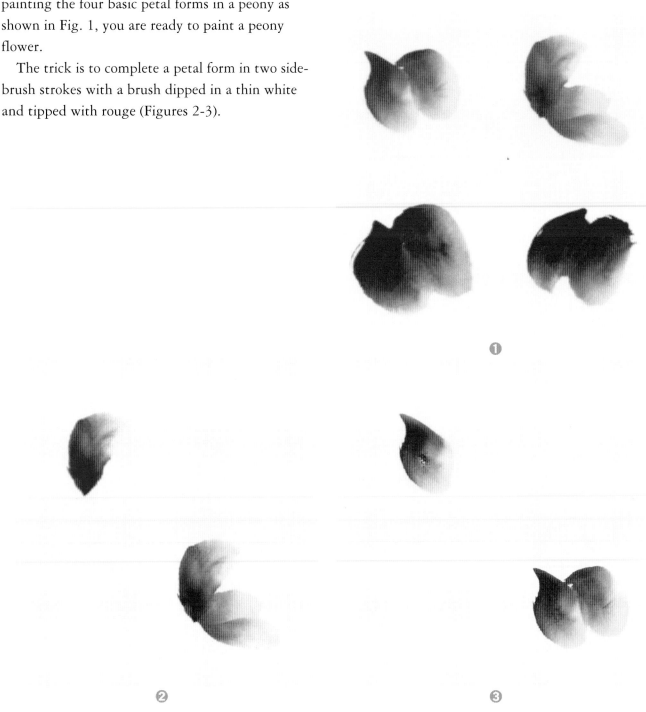

Composing a peony flower with a combination of the four petal forms

1. First paint the outer rim of the flower with a brush dipped in white powder and tipped with light eosin (Figures 1-2).

2. Switch to a brush dipped in deeper eosin to paint the flower center and the inner petals (Figures 3-4).

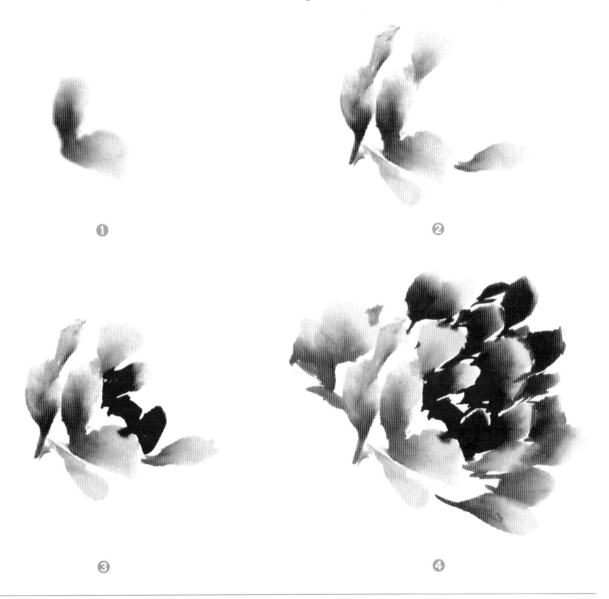

❶

❷

❸

❹

3. Build up compact layers of petals from the center outward, dabbing the outer edge in short strokes. The layers of petals should be symmetrical (equal numbers of inner and outer layers) (Figures 5-6).

4. Touch up the base of the flower with yellowish dark green. Dot the center of the flower with rouge; add some malachite dots (Fig. 7).

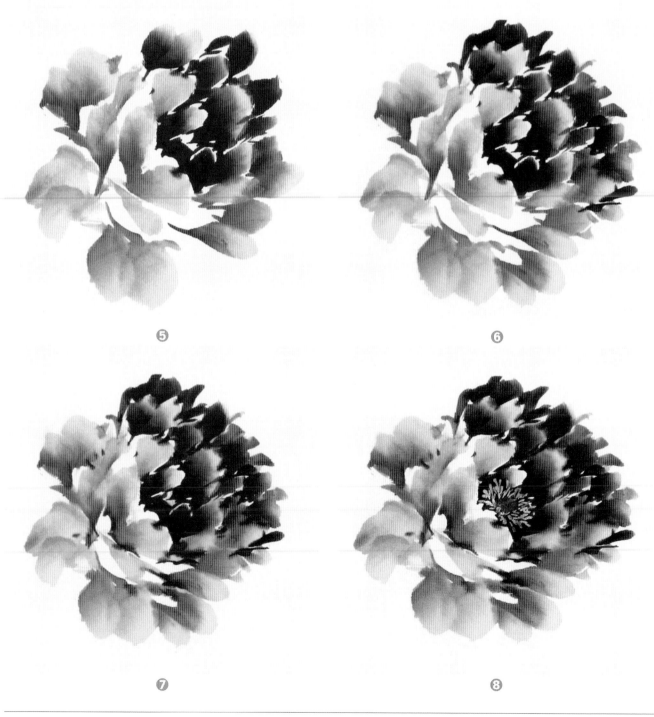

⑤ ⑥

⑦ ⑧

5. Use a thick mixture of white and gamboge to dot the stamens and anthers (Fig. 8).

6. After finishing the flower, add leaves in dark green (Figures 9-12).

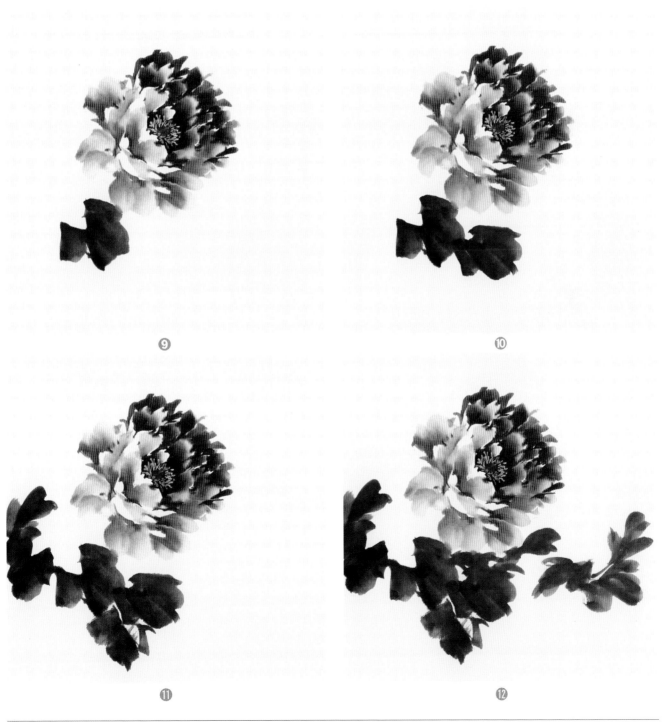

⑨ ⑩

⑪ ⑫

7. Paint the stalks and stems with ocher and ink; finish up by outlining the leaf veins with a fine outlining brush (Fig. 13).

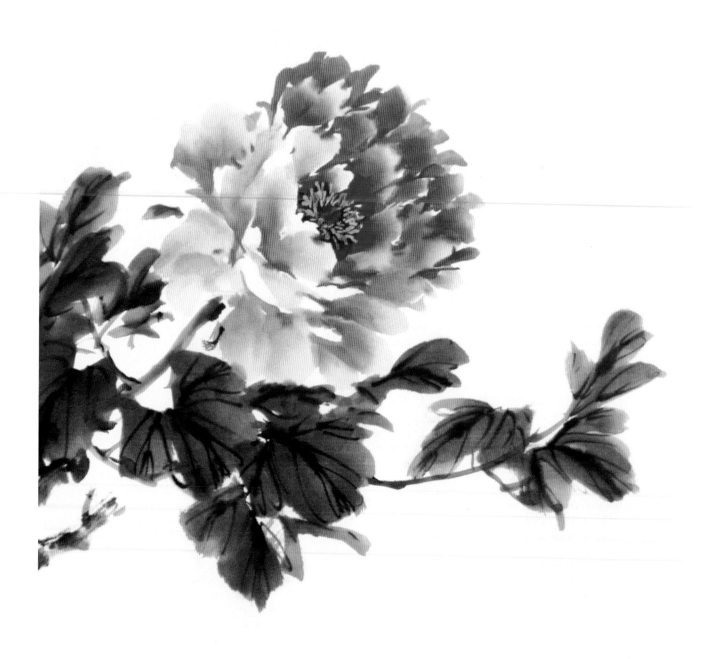

⑬

Practice the techniques of painting petals and leaves described above.

Examples of painting peony

Example 1 (Figures 1-11)

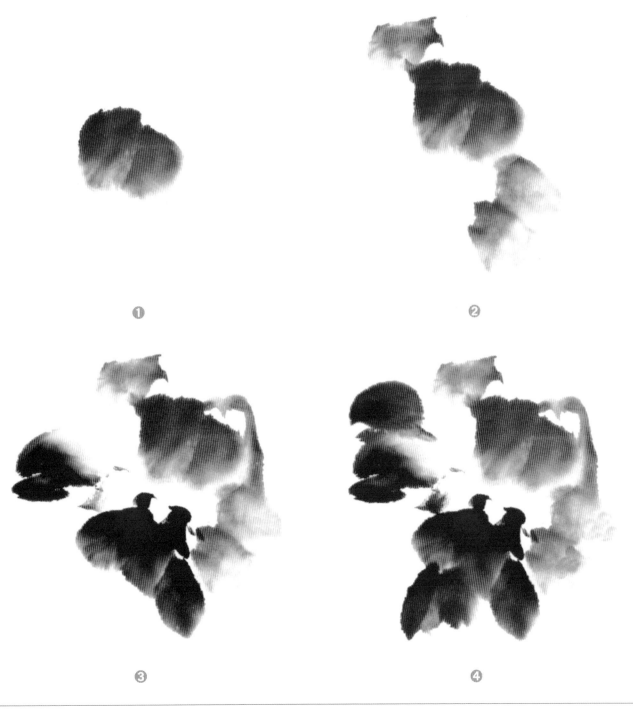

①

②

③

④

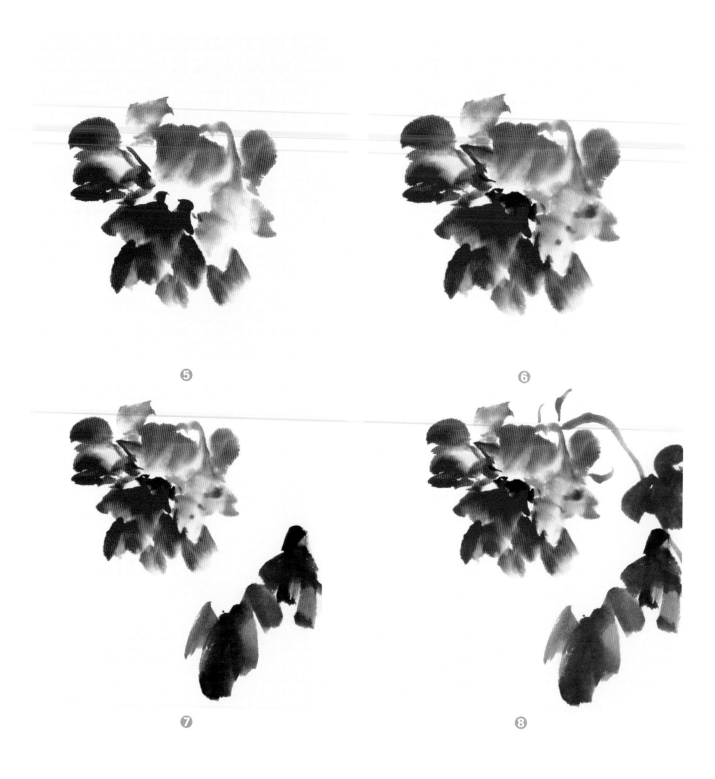

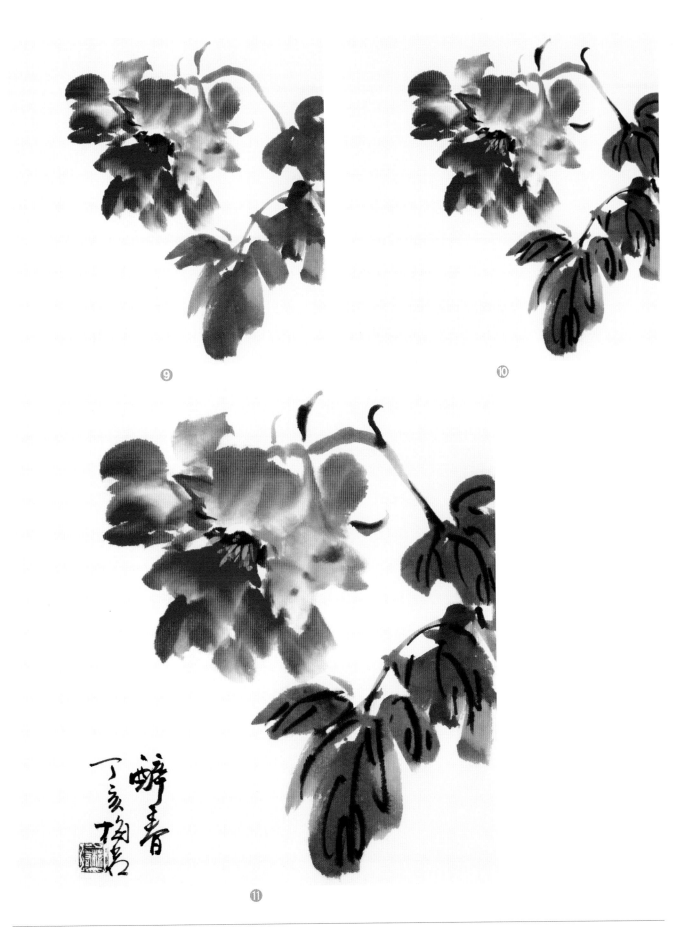

⑨

⑩

⑪

Example 2 (Figures 1-9)

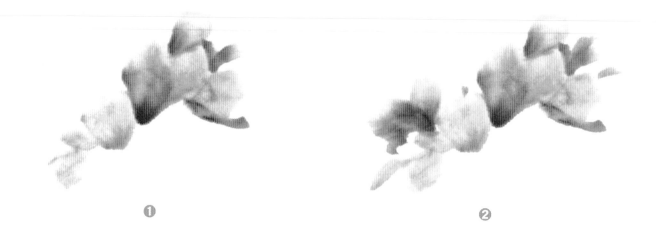

① ②

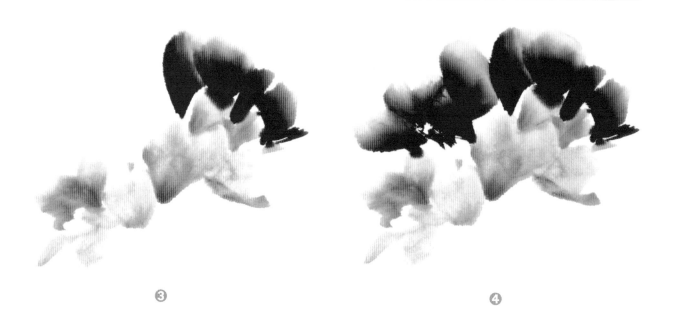

③ ④

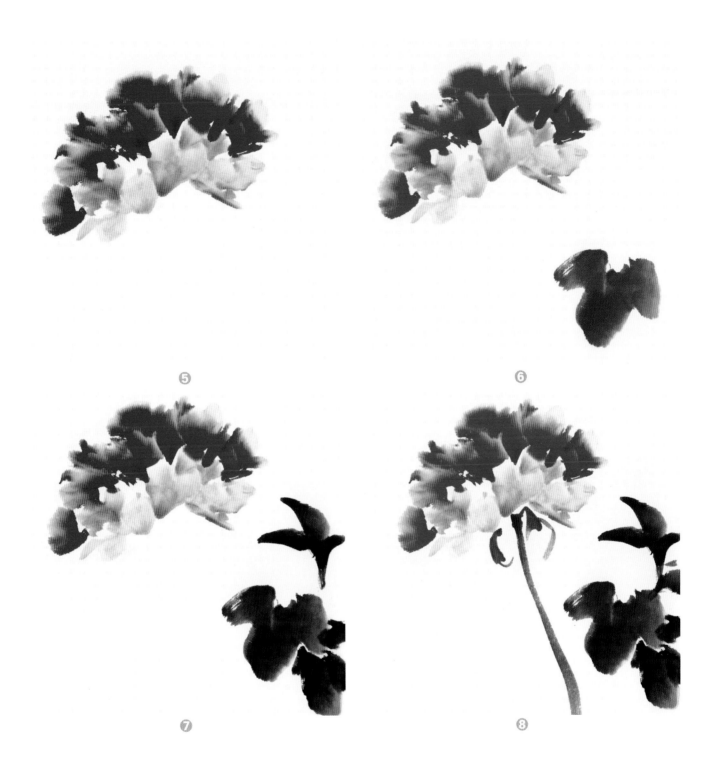

❺

❻

❼

❽

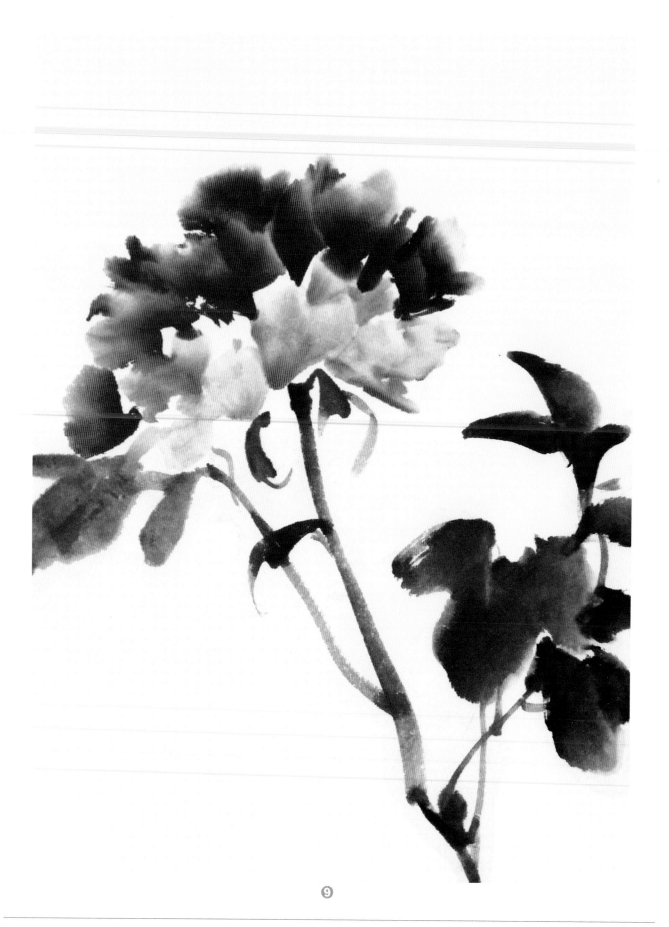

9

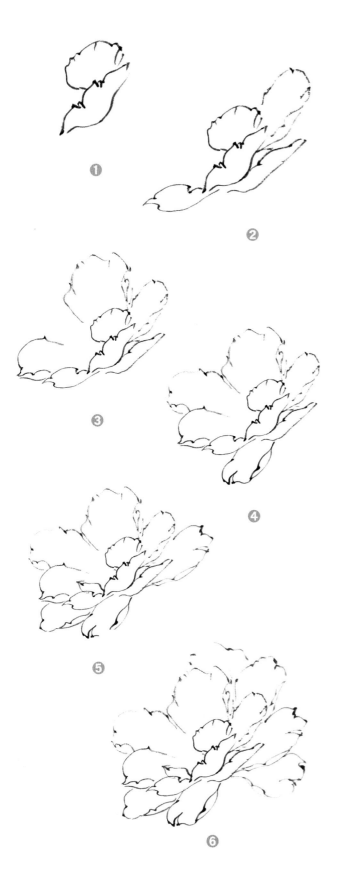

Outlining flowers and dotting leaves with the ink and wash method (pseudo-*xie yi* technique)

Xie yi, literally "writing ideas," is an important style in Chinese painting characterized by a free flowing, spontaneous minimalism.

1. Outline the flower of a peony with an outlining brush. In the pseudo-*xie yi* style, the lines should be relaxed and fluid, drawn with varied pressure from the center outwards (Figures 1-3). It is executed predominantly with centered-tip strokes, with some side-brush strokes and, less often, *san-feng* (splayed hairs) strokes, when called for, to create contrast in petal shapes. This combination of strokes will ensure gradation in line thickness, which in turn renders the flower more lively and dynamic (Figures 4-6). After finishing the outlines, use a thin dark green to touch up the petals along their edges (use a deeper shade in the middle), thus bringing out the layering and a perception of depth of the petals (Fig. 7).

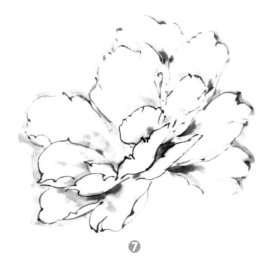

2. Paint the leaves in dark green and ink; start with the main leaves under the flower (Figures 8-9), and then paint the leaves farther away (Figures 10-11). The darker green of the nearer leaves and the paler green of the farther leaves will convey a sense of depth (Fig. 12).

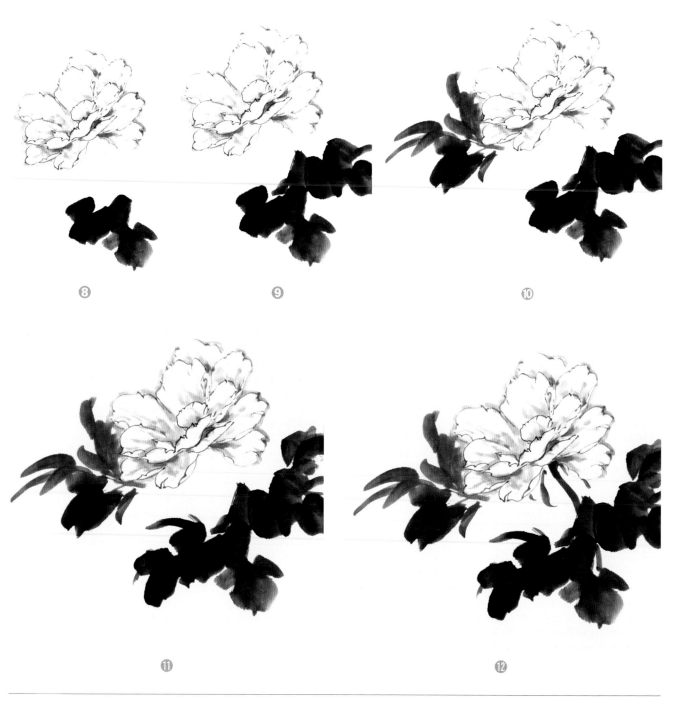

3. Outline the leaf veins with an outlining brush in darker ink; start with the main veins and move on to the branch veins, which must not be thicker than the main ones. The ink used to outline the veins on the main, darker green leaves should be darker than that used to outline the veins on the secondary, paler green leaves, to avoid a jarring effect that would otherwise result (Fig. 13).

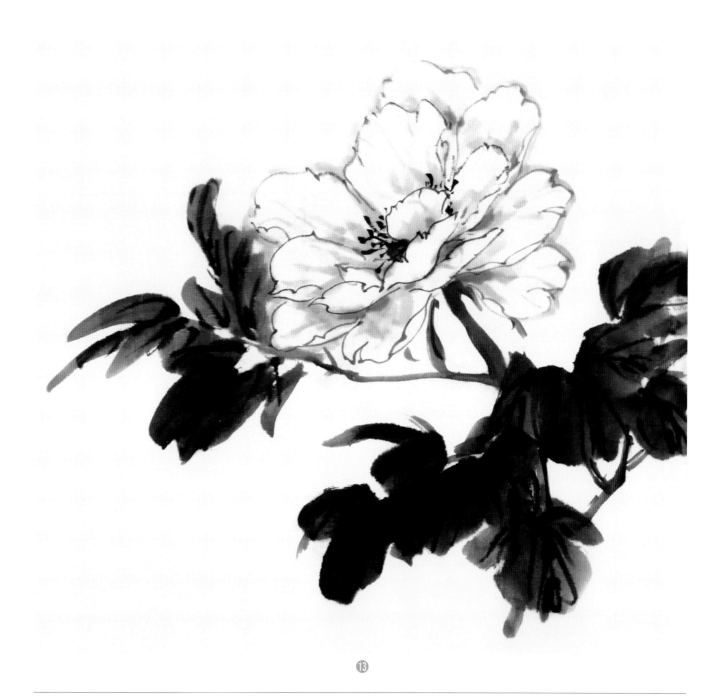

⑬

Chinese Rose

The Chinese rose is an ornamental species of the rose family. It is also called *yue yue hong* (flower in bloom every month) or *chang chun hua* (ever blooming flower) by Chinese people. This characteristic was readily celebrated in ancient Chinese poetry. There are tens of thousands of cultivars of the Chinese rose, its range of colors unequaled by other flowers. Its exquisite fragrance and delicate grace have earned it the honor of "Queen of the Flowers."

Take careful notes of the morphology, inflorescences, flower buds, branches and leaves of the Chinese rose as well as its wide spectrum of colors before attempting to paint it.

Some of the colors are white, yellow, orange, pink, carmine, red, violet, purple and multicolor.

Basic technique

1. Use *bai miao* (white drawing, without shading) to outline the shape of a Chinese rose (Fig. 1); paint the part of the petal that curls outward in deeper color and the uncurled part, which is the underside of the petal, in lighter color to distinguish the

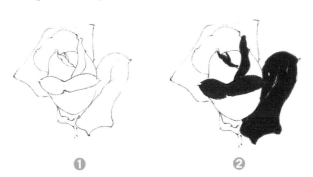

❶ ❷

upside from the underside (Fig. 2).

2. Paint the curled part of the petal in deep eosin and the underside of the petal in light red (Figures 3-4). Once you get the hang of it, painting the Chinese rose will no longer seem so daunting.

3. The flower buds of the Chinese rose are small; paint them in a deeper shade.

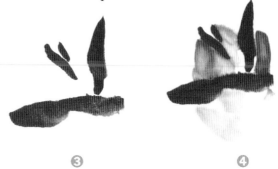

❸ ❹

4. The older branches of the Chinese rose have an earthy vigor to them and the young stems are supple. Paint the older branches in ocher mixed with ink and the young branches with a little bit of red added. Paint the barbed thorns on the Chinese rose in dark ink, but only on older stems and not on young branches.

5. The Chinese rose has whorled, odd-pinnate leaves, at least one on every petiole, sometimes as many as seven but mostly five. Among the five leaves growing on a petiole the first pair will be smaller, the second pair larger and the fifth leaf will be the largest; they are not equidistant.

6. There are smooth-edged leaves and those with bristles on their edge; when painting the latter, add a few dots along the edge of the leaf to signal the existence of the bristles.

Painting a Chinese rose

1. Paint the turned-back part of the petals in eosin (Fig. 1).

2. Dip the brush in water before painting the underside of the petals (Figures 2-4).

3. Accent the base of the flower with gamboge (Figures 5-8).

4. When painting the leaves of a flower in deeper color, the leaves should be darker as well (you may use dark ink, or if you prefer, dark green). Paint the leaves directly under the flower first, in dark ink, before moving on to farther leaves, which will be lighter in tone, thus ensuring gradation (Figures 9-11).

5. Paint the stem from the center of the flower with a brush dipped in yellowish dark green and tipped with red (Fig. 12).

6. Paint several groups of five leaves, dot the thorns, and outline the veins before the ink and colors dry (Figures 13-15).

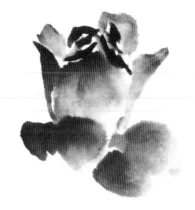

⑦

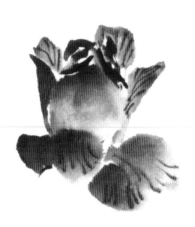

⑧

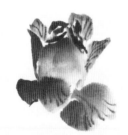

⑨

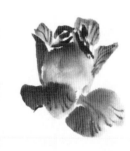

⑩

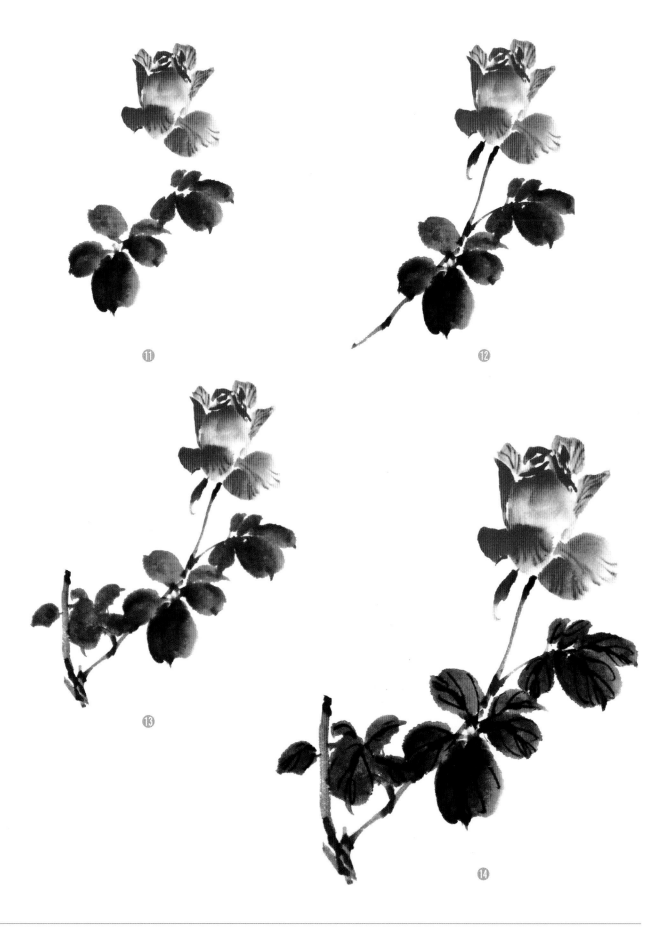

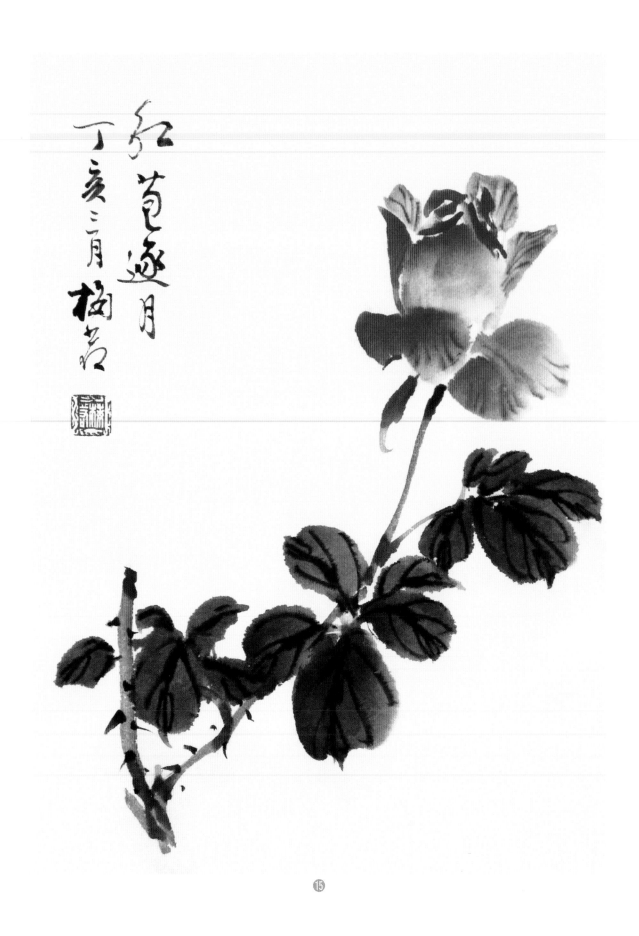

Painting a yellow Chinese rose

1. Paint the curled part of the petals with the brush dipped in gamboge and tipped with orange red in centered-tip strokes; paint the underside of the petals in side-brush strokes (Figures 1-6).

2. Add the stem. Paint the leaves in ink; arrange the leaves at various angles to ensure variation; you can add a butterfly perched on a flower (Figures 7-9).

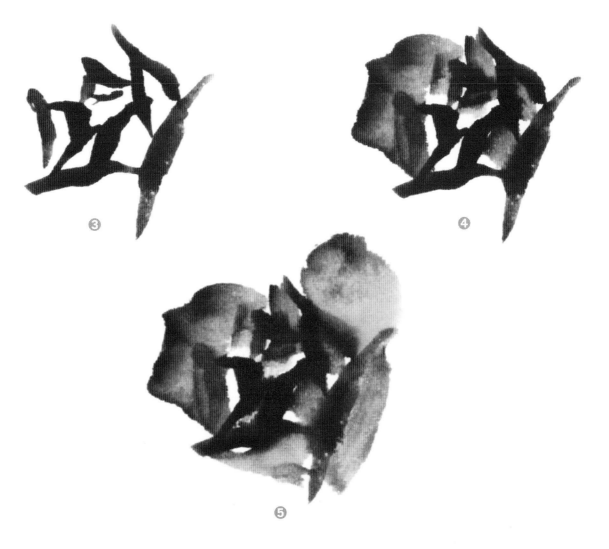

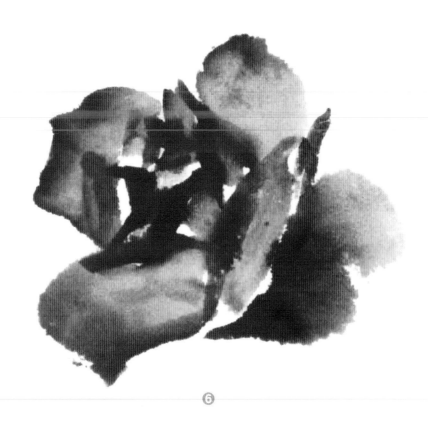

6

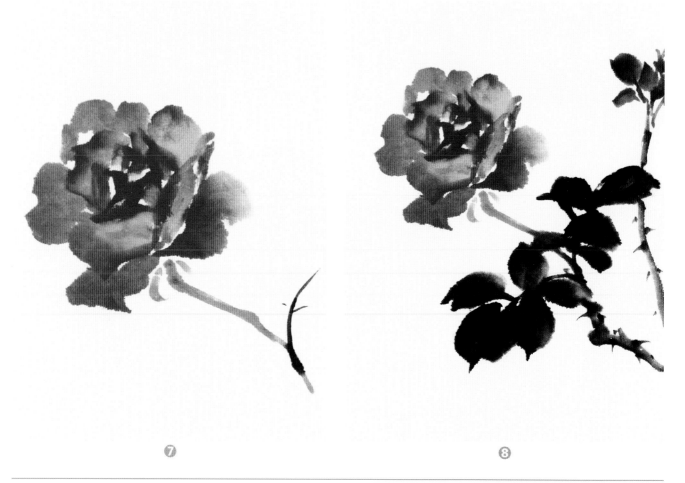

7 8

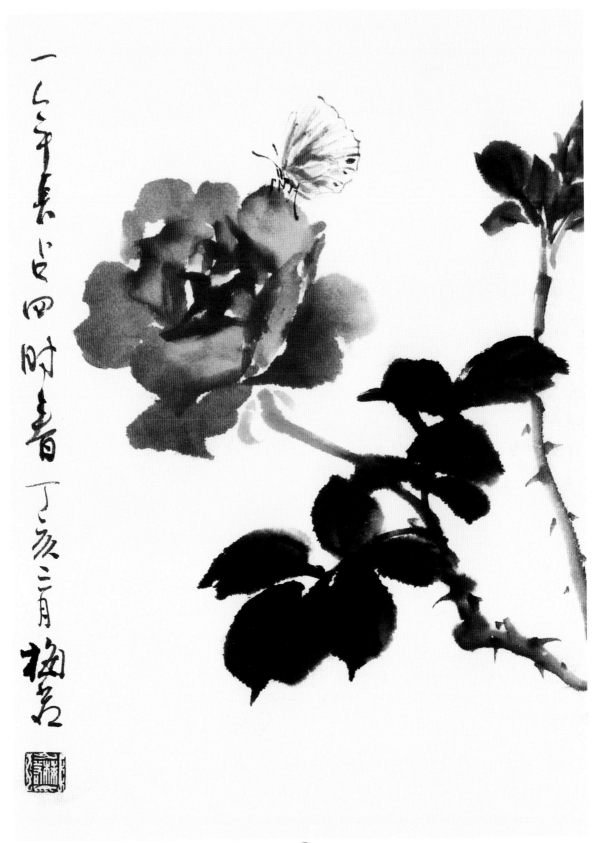

一乙年春日之四时春 丁亥三月 梅岩

⑨

Painting a Chinese rose in the *xie yi* style

1. Paint the flower with a brush dipped in rouge and tipped with ink (Figures 1-6).

①

②

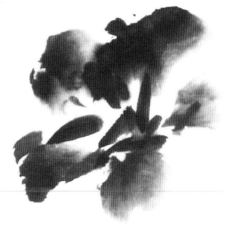

③

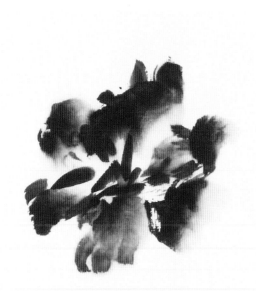

④

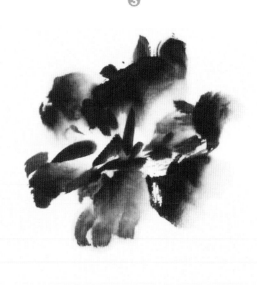

⑤

2. Paint the leaves, bearing in mind the importance of variation in ink tone and the postures of the leaves (Figures 7-8).

3. Paint the stem from the center of the flower and outline the veins before the ink and colors dry (Figures 9-10).

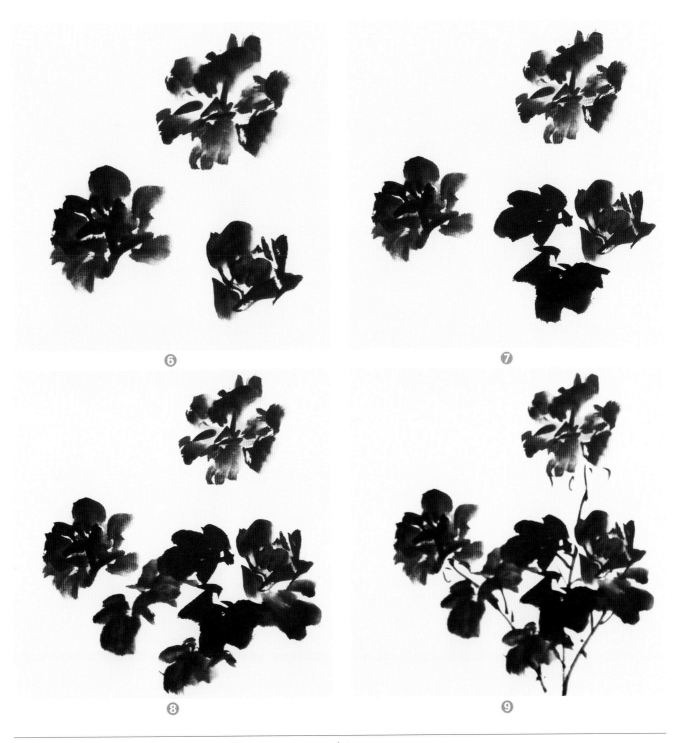

⑥

⑦

⑧

⑨

64

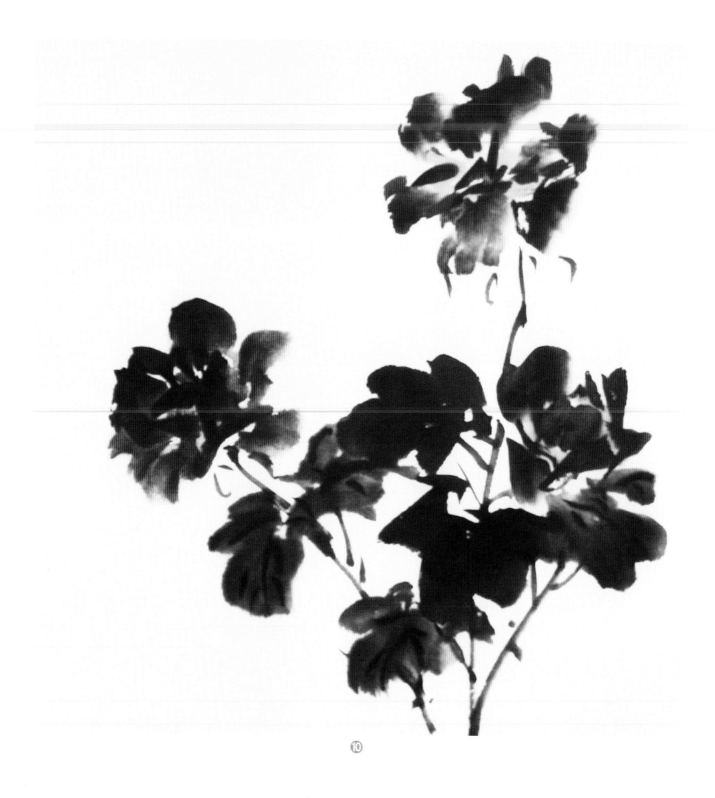

⑩

Appendices

Materials and Equipment for Chinese Painting

I. Brush

A Chinese painting brush can have soft or hard hairs or a combination of them. The brushes are made in large, medium and small sizes. The soft-hair brushes, generally of goat hairs, are very absorbent and suitable for dotting leaves and coloring. Wolf hairs make a hard brush that is tough and flexible and good for outlining leaf veins and tree trunks, among other uses. The combination brush is made of wolf and goat hairs.

The brush is composed of the tip, the "belly" (midsection), and the base (near the shaft).

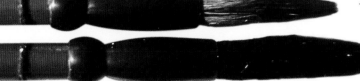

II. Ink

Chinese painting is mainly done in ink, which is made from either lampblack or pine soot. Lampblack is darker, shinier and more suitable for painting. Pine soot is flatter and more suitable for calligraphy. In the past artists used to grind their ink sticks to make ink for their paintings; nowadays most artists prefer bottled ink. Choose the ink specially made for painting and calligraphy, otherwise the ink will fade after the painting is framed.

III. Paper

The paper used for Chinese painting is called *xuan* paper (also rice paper). There are two kinds of *xuan* paper: the mature *xuan* paper, which is treated with alum to make it less absorbent, good for the detailed style of Chinese painting because you can apply many coats of colors without fear of undesirable blending; and the raw *xuan* paper, which is untreated and absorbent, and suitable for the *xie yi* style because the blending of ink and color can be used by artists to produce nuanced ink tones.

IV. Inkstone

The inkstone used for Chinese painting is made from aqueous rock, which is hard and fine-textured and produces dense ink

when ground. The *Duan* inkstone, made from stone quarried in Duanxi in Guangdong Province, is the most famous of the inkstones in China. But people have turned to the more convenient bottled ink, which produces equally good results.

V. Pigments

The pigments used for Chinese painting are different from those used in western painting, and have different names. Pigments can be classified as water soluble, mineral or stone. Gamboge, cyanine, phthalocyanine, eosin and rouge are some of the water soluble paints; mineral paints include beryl blue, malachite, cinnabar and titanium white. Ocher comes under the "stone" rubric.

VI. Accessory equipment

Water bowl for rinsing brushes, felt table cover, palette.

Use of Ink and Brush in Chinese Painting

I. Using brush

Any stroke used in Chinese painting comprises three stages: entering the stroke, moving the brush along and exiting from the stroke. Some of the strokes are *zhong-feng* (centered-tip), *ce-feng* (side-brush), *shun-feng* ("slant-and-pull-away-from-brush-tip" or "downstream"), *ni-feng* ("slant-and-push-into-brush-tip" or "upstream"), *ti* (lift), *an* (press), *dun* (pause) and *cuo* (twist-around).

The centered-tip stroke moves along the center of the ink line with the tip of the brush. To execute the side-brush stroke, the brush is held at an angle, with the tip against one side of the line (point or surface), and moves with its "belly" pressed against the paper (Fig. 1). The *shun-feng* stroke is used to paint from top downward or from left to right, while the *ni-feng* stroke moves from the bottom upward or from right to left (Fig. 2). "Lifting" the brush as it pulls along will make a lighter line. "Press" down on the brush to make a thicker and darker line. The *dun* stroke consists in pressing the brush into the paper or grinding and rotating the brush. Several *dun* strokes constitute a *cuo* stroke.

Zhong-feng (centered-tip)

Ce-feng (side-brush)

❶

Shun-feng (downstream)

Ni-feng (upstream)

❷

II. Using ink

In Chinese painting it is important to master the use of the following five gradations of ink: dark, light, dry brush, wet brush and charred (burnt).

Dark ink: Add a small amount of water to the ink to make a dark shade;

Light ink: Increase the amount of water in the mixture to make a grayish ink;

Dry brush: A brush that contains only a small amount of water can apply either dark or light ink;

Wet brush: The brush contains more water and can also apply either dark or light ink;

Charred ink tone: Very black shading that creates a shiny black effect on the paper (Fig. 3).

Dark ink

Light ink

Dry brush

Wet brush

Charred ink tone

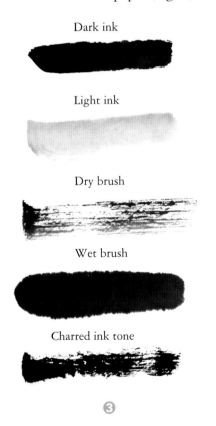

❸

III. Brush and ink

Brush and ink are mutually reinforcing. The use of ink is just the other side of the brush use.

The wetness or dryness of the ink translates into the wetness or dryness of the brush to communicate the "spirit of the ink." The use of ink and the use of the brush are closely interdependent.

It is important to bear in mind these six words when using the brush: *qing* (light), *kuai* (fast), *ce* (side), *zhong*[1] (heavy), *man* (slow), *zhong*[2] (center).

Qing: Lifting the pressure on the brush while the stroke is in progress;

Kuai: Shortening the time of the stroke;

Ce: Using the *ce-feng* (side-brush) stroke;

Zhong[1]: Pressing down on the brush while the stroke is in progress;

Man: Increasing the time of the stroke;

Zhong[2]: Using the *zhong-feng* (centered-tip) stroke (Fig. 4).

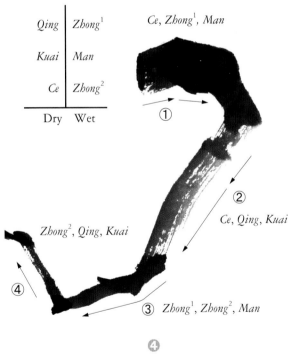

	Qing	Zhong[1]
	Kuai	Man
	Ce	Zhong[2]
	Dry	Wet

Ce, Zhong[1], *Man*
①
②
Ce, Qing, Kuai
Zhong[2], *Qing, Kuai*
④
③ *Zhong*[1], *Zhong*[2], *Man*

❹

It is common sense that when the brush has been soaked in water, whatever liquid in the brush will flow down faster when the brush is held upright and will run more slowly when the brush is held at a slant. In a centered-tip stroke the upright brush is pressed down and pulled at a more leisurely pace, the ink will consequently have ample time to be

absorbed by the paper and what results is a wet stroke. If the brush is held at an angle and is not pressed as hard against the paper and is pulled at a faster pace, there is less time for the paper to take in the ink; what results then is a "flying white" (broken ink wash effect), namely a dry stroke. It is therefore essential to learn how to properly manipulate the brush and ink.

IV. Different kinds of brush strokes and ink tones in the painting

The tree trunk sample offers an analysis of the different kinds of brush strokes and ink tones employed in the painting (Fig. 4) . This is a difficult example and it takes long practice to master enough skill to successfully execute it, because it requires the use of a combination of strokes such as the side-brush, flying white, the dry-brush, the centered-tip stroke, the wet-brush stroke, etc. Always pay attention to how you enter, execute and exit a stroke and remember the importance of variation in stroke speed, pressure, ink tone and wetness as well as balance in the use of strokes to compose a painting: stroke left before stroking right, stroke right before stroking left, stroke down before stroking up (Fig. 5) or stroke up before stroking down (Fig. 6).

Another technique used in Chinese painting is the *po mo* method (breaking the preceding application of ink), which consists of applying dark (light), wet ink over a preceding application of light (dark) ink before it dries. This method will impart a sense of lively variation and wetness to the painting. You can break light ink with dark ink or vice versa.

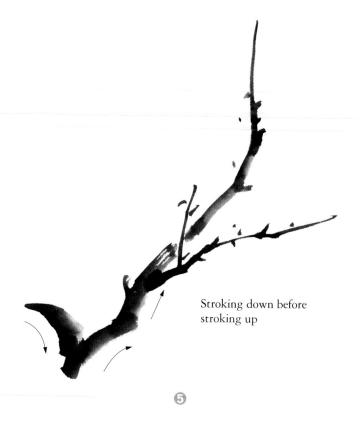

Stroking down before stroking up

⑤

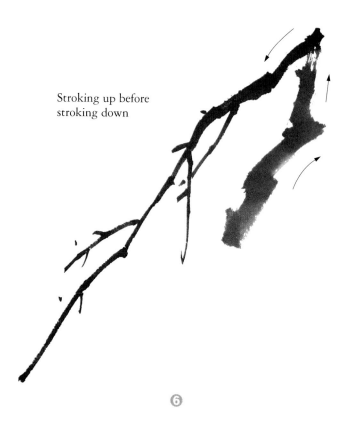

Stroking up before stroking down

⑥

68